T0163068

the wishing ceremony sally sheinman

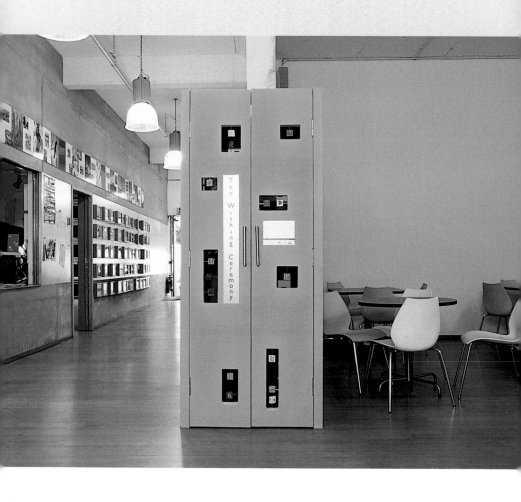

I wish I had a thousand wishes and I wish for everything I dream of

introduction sanna moore

I first became aware of Sally Sheinman's work in early 2002 when I received a touring proposal for an exhibition called *Days* at The Gallery, Stratford-on-Avon. I was immediately struck by the simplicity and touching nature of the concept. Although we were not able to be part of the touring programme for *Days*, I began to talk to Sally about developing a new idea for an exhibition. That exhibition became *The Wishing Ceremony*.

The Wishing Ceremony, a collection of six brightly coloured booths housing wishing tokens, invites the visitor to step inside and make a wish. A selection of wishing tokens hang in each booth, square in shape and individually hand-painted; each token acts as an inspiration to make a wish. After touching the wishing tokens you are invited to leave a hand-written version of your wish (anonymous of course) attached to the wall of the booth.

The wishes build up during the course of the exhibition, each one noted and recorded by the artist after the exhibition has closed. By creating an oasis of calm in a chaotic world, Sally provides a space for a moment of silent reflection and quiet contemplation, an opportunity for each visitor to lose themselves for a few minutes within the structure and focus on their own thoughts. Like stepping into a confessional, we can unleash our innermost desires and simultaneously read and absorb the intimate desires left behind by others. There is a sense of intrusion into the mind of a stranger but we have been invited, almost encouraged, to intrude into others' thoughts.

There is no getting away from the quasi-religious nature of this installation. Religion gives hope as does *The Wishing Ceremony*. Hope is a religion which everyone can adhere to without the complications of faith. Wishing is universal: if we don't wish, we don't hope or aspire to something better.

Sally often works in series. *Days* represented one event, emotion or sensation each day for a year of her life, 365 in total. Each day was embodied by a painted box and a written thought. *Sacred Vessels*, 2003, was a series of 49 drawings with titles and descriptions constructed by the artist. In *The Naming Room*, 2001, the visitor was invited to name the paintings and, similar to *The Wishing Ceremony*, Sally painted over 1000 wishing tokens, hanging a selection in each booth to encourage the visitor to wish. The words, in this instance, are supplied by the visitor.

Sally likes to give visitors something to think about, she encourages interaction between her work and her audience. Her process of working is very meticulous and controlled yet she likes to throw the work open to the public for interaction. She then loses control of the work, and it becomes dependent on the interaction of the visitor.

Hope is the central theme in all of Sally's work, as is spirituality. Without wanting to tie herself to any particular religious faith, she takes her inspiration from human nature. In *The Wishing Ceremony* you step into the booth and stay for a while, leaving a part of yourself behind, but at the same time by making your wish you leave with an element of hope. We all wish for something, but be careful what you wish for, it might just come true…

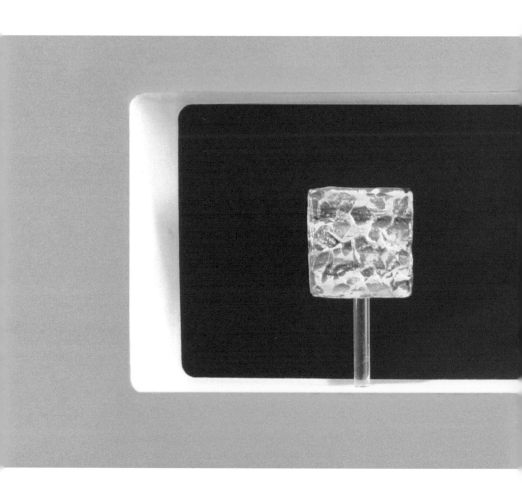

I wish Leeds united would return to the premiership

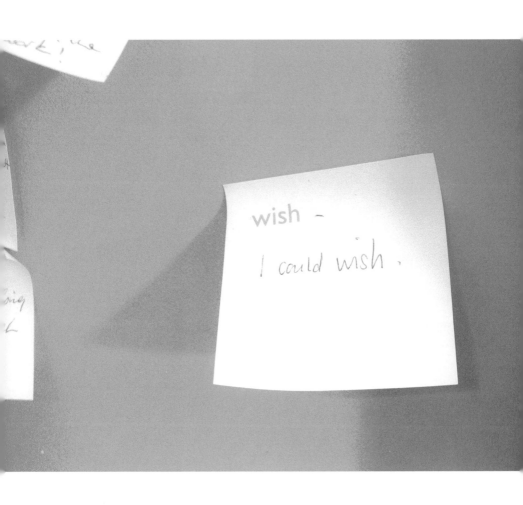

I wish I had bigger breasts and a flatter stomach

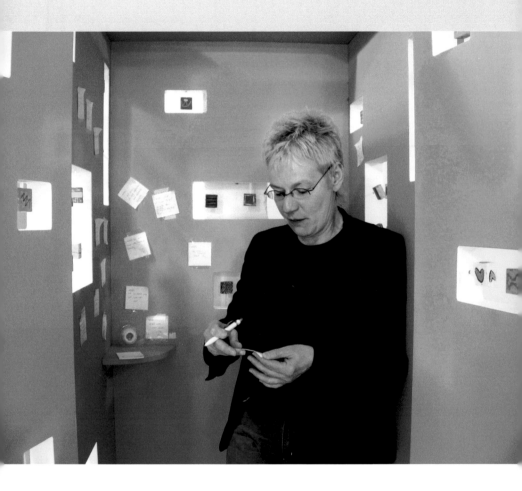

I wish there were two of me – so much to do

sally sheinman

the wishing ceremony laura gascoigne

Of all the capacities that distinguish us from the higher mammals, perhaps the most fundamental is the ability to wish. 'Homo sapiens' is almost certainly a misnomer for the human species; a better name might be 'homo optans' – 'wishing man'.

The ability to wish could be regarded as humanity's greatest asset and its greatest loss, since it marks the parting of the ways between desire and gratification. As newborn infants we wish for milk, we cry, our cry summons the genie in the baby's bottle and we sink back satisfied in the blissful belief that the world exists for our personal pleasure. Sadly, the illusion doesn't last, but our awakening to reality would be ruder were it not for the blessed mechanism of wishing, a sort of psychic equivalent of thumb-sucking designed to wean us gently off solipsism.

Today, many artists feel it is their duty to strip away illusion and confront us with grim reality. Sally Sheinman disagrees. She believes that life is hard enough already, so instead of making work about its dark side she has made *The Wishing Ceremony*, a work about wishing.

Sheinman is fascinated by the tradition of wishing stories – from the *1001 Arabian Nights* to *Harry Potter* – on which we cut our imaginative teeth as children. In 2003, for her exhibition *Sacred Vessels*, she created a series of images of ancient vessels credited with containing all manner of remedies for human ills. One vessel, no 13, was said to hold a gum 'in which the secret prayers of the worshippers were written on a piece of fragile cloth and then sealed with the gum and placed in a blessed receptacle and left to disappear over time'.

This vessel, as it happens, also contained the seeds of the idea for *The Wishing Ceremony* – except that in its present incarnation the fragile cloth has been replaced by a post-it and the blessed receptacle by a brightly coloured wishing booth decorated with gaily painted tokens. In June, six of these booths appeared around Leicester, in locations ranging from an office and a leisure centre to two schools, a regional arts training HQ and the Pakistan Youth and Community Centre.

In her earlier interactive installation, *The Naming Room*, Sheinman invited the public to name the pictures; now she has asked us to name our desires. Even under the cloak of anonymity, this isn't as simple as it sounds. Spending lottery winnings may be a piece of cake, but spending wishes is a tricky business requiring serious thought. As the fairy stories show, you can easily mess up. You can fritter your wishes away, like the woodcutter in the old folk tale *The Three Wishes*, who wasted his first wish on a sausage, wished it would stick to his nagging wife's nose, then had to spend his final wish unsticking it. Or you can be greedy, not know when to stop and end up miserable as Emperor of the World.

The really tricky thing for an adult wisher – as I discovered when someone recently sent me a wishing chain email – is to find a wish that fits in with everyone else. Wishful thinking is all very well when you

have no power to make your wish come true, but add an element of magic, and imaginative freedom gets bogged down in personal responsibility. In the end, I blew my options on a stupid wish for a job that would pay twice my current earnings for half the work. It didn't happen, of course. Instead, an invitation arrived from Sally Sheinman to write the catalogue introduction for her show about wishing.

Having arranged to meet at Leicester Creative Business Depot, I had my first sight of Sally through a hole in a saffron-coloured wishing booth that had landed like an exotic Tardis in the cafeteria. By then, I was so absorbed in reading the wishes that she had to come over and winkle me out. 'I wish my uncle would pull through'; 'I wish for a long hot summer'; 'I wish I had bigger breasts and a flatter stomach'; 'I wish I could complete my house purchase' – between the touching, the silly, the mundane and the shamelessly selfish, all of human life appeared to be there. 'I wish there could be something ultimately selfless to wish for,' wrote one wise wisher. I sympathised, and suspected Sally, but she said her wish would be for sticky post-its. Some had lost their stick and drifted to the floor, like petals, but Sally remained philosophical: 'I don't want them to last forever. If one gets carried away in a breeze, that's especially nice. It's a living thing: if it loses some of its parts, that's how things are.'

A sensible attitude for anyone undertaking an interactive art project in a public space, especially a place like Braunstone Leisure Centre, the venue Sally confessed to being most nervous about. On entering the lobby, you could see why. Five vending machines were lined up against the wall – dispensing sports accessories, soft drinks, snacks, more soft drinks and yet more soft drinks – and behind them, in direct competition, stood a sixth machine, a bright green painted booth dispensing wishes.

Sally needn't have worried; it wasn't short of custom. Wishes plastered the walls, like message-boards to God, and overflowed into graffiti inside and out. The post-its had run out, so had the pens, and some wishing tokens had gone walkabout. There was the usual piquant mix of wishes, but one stood out from the rest for its sheer completeness: 'I wish that D was my boyfriend tomorrow and he told me his feelings and he told me in registration. Thank you.'

As we were leaving, a teenage girl sitting with her mother came across to us with shining eyes. 'You know these wishes…' she asked. 'Do they come true?' We mumbled something about the wishing being the main thing, and as she wandered off looking hopeful, the same thought struck us. Would there be whispers in registration? Wish we knew.

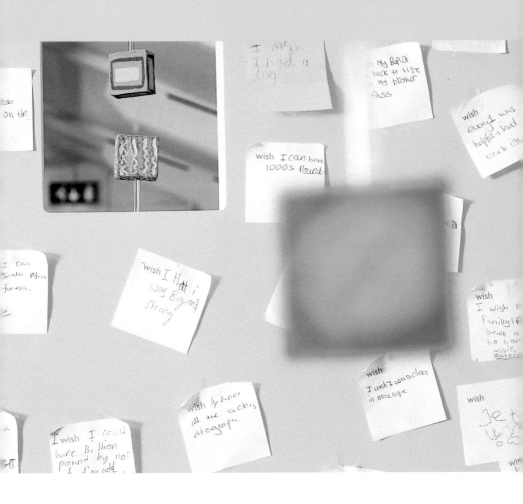

I wish I had £10,000

I wish I was a millionaire

I wish I had £3,000,000,000,000,000.00 so I can be rich

wish

I wish I
get better in

Maths

I wish for my step dad to be kind

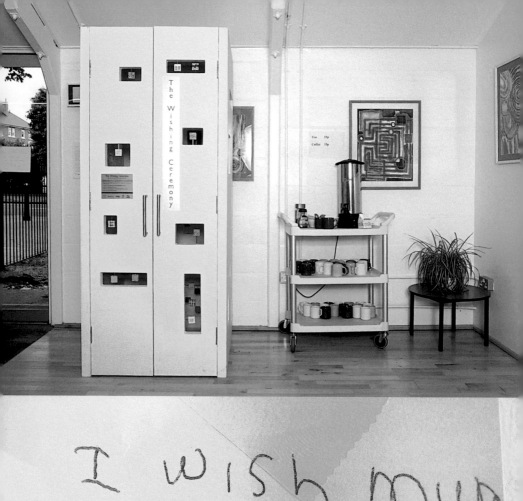

I wish mum let me haf a dog.

conclusion fiona clayton

When Sally Sheinman first approached me about bringing her new work *The Wishing Ceremony* to Leicester, I was delighted and intrigued. I knew of Sally's work from having seen *Days*, a fascinating and beautiful exhibition representing a year of Sally's life; 365 small paintings, uniform in size but each expressing an emotion or experience of a different day in the year 2001. Some of the paintings represented ordinary, mundane days, the sort we usually forget; others were about days that remain in our memory forever such as September 11th.

About seven months after this initial conversation, I found myself standing inside a bright orange wishing booth in Leicester's Creative Businesses Depot, reading the post-it wishes, and I was reminded of *Days*. The wishes were as varied in emotion and content as Sally's paintings had been. There were sad, heartfelt wishes, funny wishes, decadent wishes and simple wishes. I pondered about what to wish for myself and decided, on this grey day in June, for a long, hot summer. This felt like an honest contribution but light-hearted and not too intense for a normal Tuesday morning.

In the early days of *The Wishing Ceremony*, when Sally and I discussed the various venues in Leicester where the booths might be installed, I wondered how people would react to an invitation to write and display their wishes, albeit anonymously. Sometimes just thinking about what we most desire can be disquieting, even painful. Were we being a little irresponsible in even offering the invitation, especially when we had no way of bringing those wishes to reality? Would the project just be stirring up emotions or, on the other hand, would people take part when it required them to step inside a brightly coloured 7ft high box placed in a public space; would they feel too embarrassed, too seen? To my delight, as the weeks went by the walls of the booths gradually filled with wishes reflecting the varied lives of people in Leicester and the different locations in which the booths were placed. The booths themselves drew people to them; the strong colour and sturdy structure contrasted against the cut-out windows and intricately painted tokens. People were curious and, given the opportunity to wish and to dream, people of all ages wanted to take part. *The Wishing Ceremony* allowed us to share our wants, yearnings and preferences and to glimpse into other people's heads and hearts, eliciting a whole range of reactions and feelings.

I want to thank Sally for her vision, patience and generosity of spirit. I want to thank the managers of the six venues that hosted the wishing booths and responded to our unusual request with open minds. Finally, thank you to everyone in Leicester who took part and shared their wishes. As I look out of my window I see the sun has come out – maybe my wish is coming true.

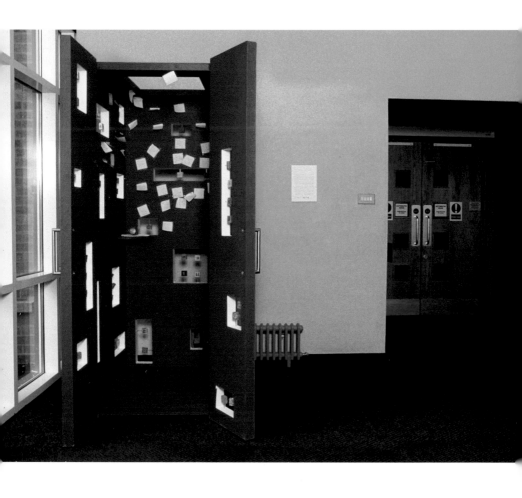

I wish that I was nice

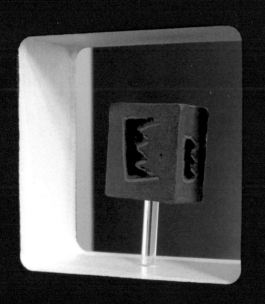

I wish I could tell him how I feel

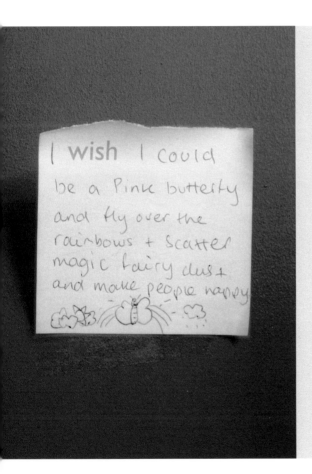

I wish for endless love

I wish I could stop feeling depressed and be happy

I wish I could have an affair and get away with it

I wish my sister could walk

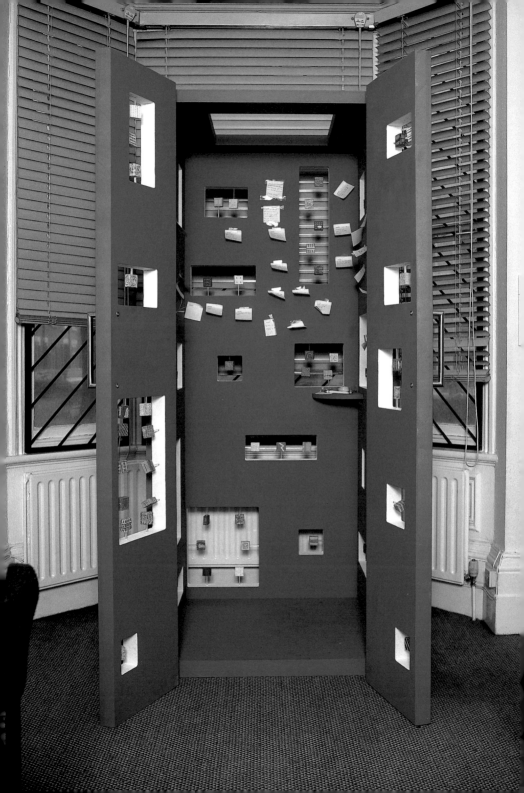

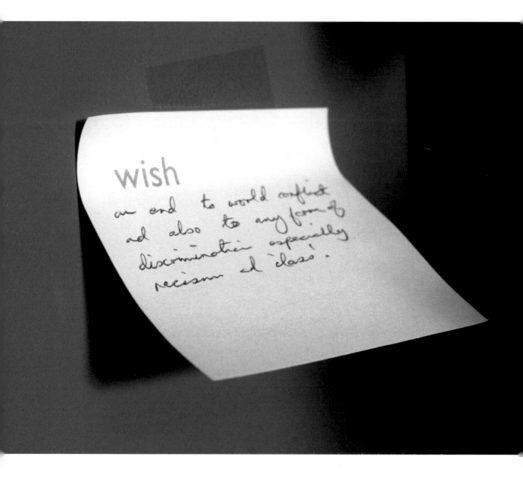

wish

an end to world conflict
and also to any form of
discrimination especially
racism and class.

I wish I could go out with _____ she is so so so so so so
so so so so so so so so so so so so so so so so so so so so
so so so so so so so so so so so so so so so so so so so so
so so so so so so so so so so so so so so so so so so so so
so so so so so so so so so so so so so so so so fit

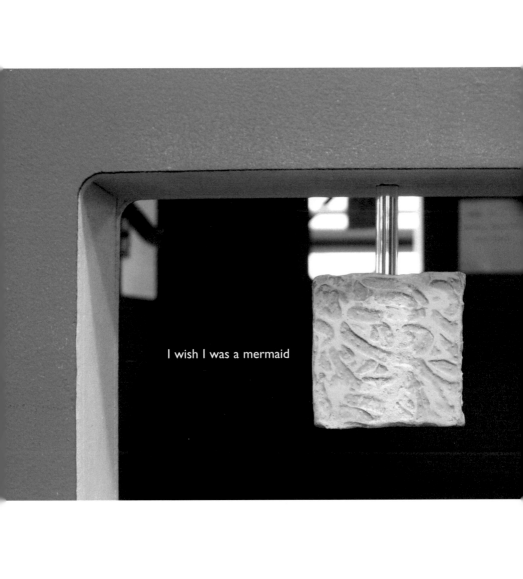

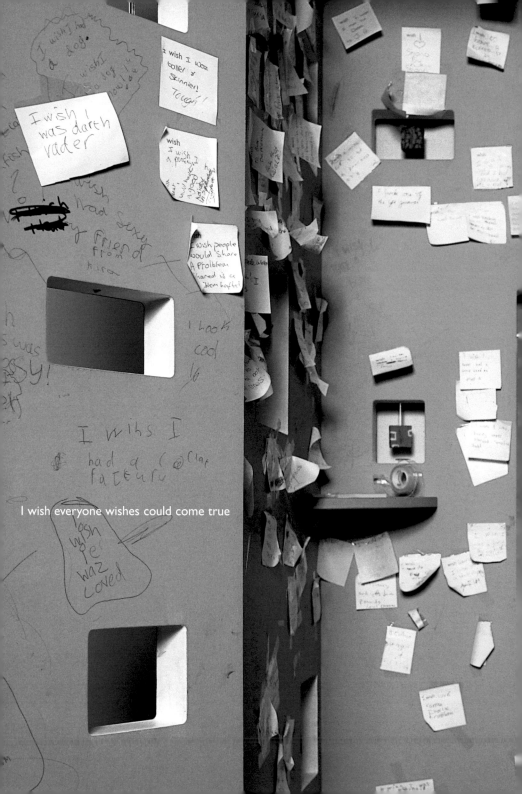

I wish everyone wishes could come true

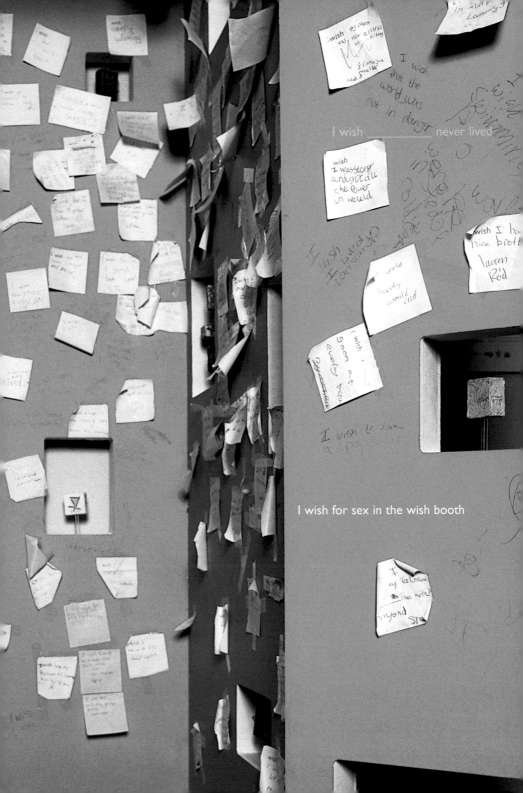

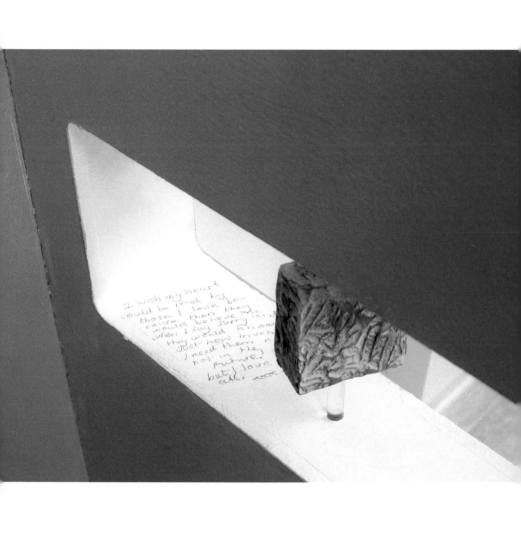

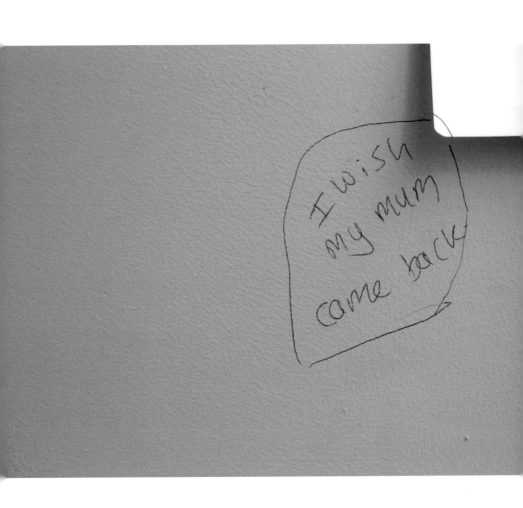

I wish there was enough time to read every book I'd like to

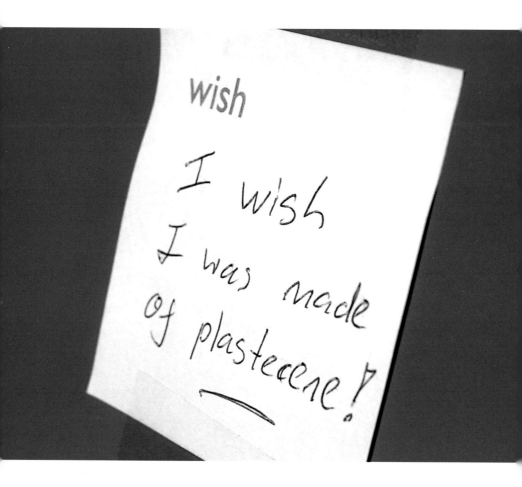

I wish everyone gets home safely today

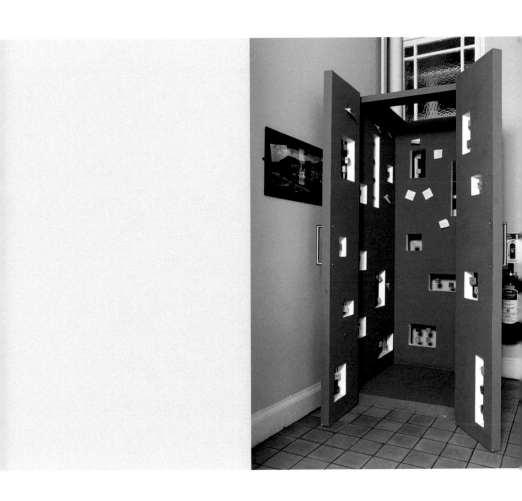

I wish for lots of babies

I wish it would stay hot and sunny till October

I wish that I could stay here hidden forever

I wish that I will have a nice time on holiday

I wish I got better in maths

I wish I have all the actors' autographs

I wish I won the lottery

I wish I had a fish pet

I wish I had £10,000

I wish I had £1,000,000

I wish I was clever in mosque

I wish I was perfect at everything

I wish I do not get in trouble in mosque

I wish I could have better friend and best friend

I wish my_____ would came back to life

I wish we never had to do work

I wish my uncle pulls through

I wish that all of it turns out nice and I get this beeswax out of my coat sleeve (maybe)

I wish for sex in the booth

I wish that my business is successful

I wish that when I die I'll be giggling

I wish I could afford more shoes (and world peace)

I wish I could go out with _____ _____

I wish I was a singer and dancer

I wish my house was made of chocolate

I wish I was an air hostess on Concord

I wish for more pension

I wish that my family was back to normal

I wish that I didn't get caught smoking by my Mum

I wish I was pretty and my Mum loved me and my Step-dad

I wish I was a mermaid

I wish I had a bed

I wish I was in the RAF

I wish I could have my old dog back

I wish I had an airplane

I wish I had a motor bike

I wish I had 3 ginger kittens

I wish I didn't have a tooth gap

I wish that none of my family never died

I wish I was a princess

I wish I could show people my art

I wish I was killed

I wish my Mum would come back

I wish no one called me grease ball

I wish I was a cartoonist

I wish Bob the Builder was on all the time

I wish I was 3

I wish I could see DAD again

I wish _____would let me have a cat

I wish I do well in my interview this morning

I wish I could win a medal at tonight's gala

I wish who ever wishes they were me

I wish I was Darth Vader

I wish I was taller and skinner

I wish I had a father

I wish people would share a problem a problem shared is a problem halved.

I wish I had a dog

I wish that I would have a good holiday

I wish to be a pop star and famous

I wish Mum was not allergic to kittens

I wish I had a boyfriend

I wish I didn't need to wish I can be happy with what I have

I wish I played for Liverpool

I wish my Gran was nice to us

I wish I was strong and got all the power in the world

I wish world poverty would end

I wish I was good at everything

I wish I had a nice brother

I wish I was a good dancer and was nice

I wish you wouldn't stand on me

I wish I had every talent in the world

I wish I was happy and had a lot of money

I wish that all my family and relatives would be rich and happy and that I grow up and be a successful person I wish my family and I will always be happy

I wish I will have a good party

I wish that _____ would stop bullying me

I wish I had 8 brothers that were nice to me and not horrible ones

I wish child cruelty would stop

I wish someone would kiss me

I wish my Mum would win the lottery

I wish that I could be a better dancer and singer and when I grow up to be a holiday rep and live abroad

I wish I was older and taller

I wish I had what I wanted

I wish we can sell the house quick for the right price

I wish that I was superman

I wish I was sexy

I wish that me and all my family will live long and happy lives

I wish I had a car

I wish I could get a decent job

I wish some adults would stop taking children away

I wish I could be a better at gymnastics

I wish I was a fairy with fluffy wings

I wish I was good at football

I wish I could do more

I wish I had a lifetime supply of cheese

I wish that one day I will become an artist

I wish I was rich and had a posh home

I wish I could stay young forever

I wish it was Christmas and my Birthday

I wish I had a black puppy

I wish I was famous

I wish _____ knew I lived

I wish I was you

I wish I was tall

I wish that my sister was still alive

I wish I went out with the boy across the street

I wish people would stop bullying me about my dumbo ears

I wish that everything was made of money itself of good and sweet chocolate and crisps

I wish that I have good luck forever

I wish I could go to Narnia

I wish my Mum could get together money to go shopping

I wish success was guaranteed so we could all chill out and relax

I wish I was made of plastecene

My wish is that one day I will own a shoe shop

I wish we had two ladies toilets

I wish I could tell him how I feel

I wish people would look after one another

I wish summer would come soon

I wish I do well in my life by not letting others go through what I have had to go through

I wish I could live somewhere warmer

I wish there were two of me – so much to do

I wish to be successful and happy

I wish for love – love this booth

I wish that he would love me like I love him

I wish that I got my job that I want at Disney

I wish _____ (16) recovers from his brain tumour

I wish I get good grades in my GCSEs

I wish my kids grow up happy and healthy

I wish I had a best friend again

I wish there was no wars ever

I wish one day I could go to New York

I wish my car would get better and stop costing so much money

I wish I had a student who listened to instructions the first time

I wish my friend's Mum would be okay and get better

I wish that I would do well in my next trampoline competition

I wish that someone would love me

I wish hopefully to go out with _____ and _____

I wish I was a spag

I wish that I will be loved by my friends and that they stay true to me plus peace in the world and happiness

I wish I could have an affair

I wish that _____ would ask me out

I wish I was Miss _____

I wish that I had all the cards

I wish that there was no war and that there was no pollution

I wish I could do magic

I wish my sister would be restored to good health

I wish for a world peace and happiness where there was no poverty and armies had to have jumble sales of guns

I wish I had a horse in my garden

I wish to be a mother

I wish I win the lottery last night

I wish my name was Amy

I wish everyone wishes could come true

I wish for world peace food for everyone and that all the children in the world are loved and watched over while asleep

I wish for a baby brother

I wish everyday was new and exciting as possible

I wish I could do anything I want

I wish I was an animal

I wish I could fly

I wish I can be best footballer and I can have a playstation 2 with all the games in the world

I wish I have a billion thousand money and a bike

I wish _____ would play with me

I wish I could be happy all the time

I wish for success for our students in their exams and in their future choices

I wish that I pass my exams

I wish _____ has a baby

I wish my daughter better

I wish an end to world conflict and also to any form of discrimination especially racism and class

I wish I have super strength and laser eyes

I wish that you would wish

I wish to be good in maths and English and I want to speak English

I wish I had the fastest car in the world and be good in maths

I wish all the people around the world who are dieing get much much better

I wish I have everything in the world

I wish I will be happy and have a happy family

I wish I am the cleverest boy in the world

I wish we could all learn to live together on this planet before we start travelling to other ones

I wish for better eyesight

I wish that all my dreams come true and _____ _____ is free man

I wish for endless love

I wish for a permanent home which is happy for years to come

I wish for a new kitchen

I wish there could be something ultimately selfless to wish for

I wish to be able to get a new job

I wish that the bastard bank would actually conduct themselves with professionalism and treat their customers with the respect they deserve after all it is our bloody money (excuse the swearing)

I wish my horse goes well

I wish for eternal orgasms

I wish for all to know imagination

I hope _____ and _____ get it sorted

I wish to marry

I wish that regardless of my circumstances I retain inner happiness and resilience to just get on with life. If that is too much to ask for free wine for life would be just fine.

I wish for the sun to smile on all of us and for everyone to have a magical summer

I wish for a successful Caribbean Carnival 2005

I wish I did not have to put up with this pain in my hip

I wish my daughter is happy and healthy

I wish for my dreams to come true

I wish that everyone in Africa live life happy

I wish for world peace and world hunger ends and evil things do not occur

I wish for a good woman to look after me with a killer body

I wish everyone feels happy and content even when things are not going well for them

I wish to smile and let the sun come out and take away your blues

I wish _____ would notice our dancing

I wish the mortgage paid off

I wish upon a star for twinkles in everybody's life

I wish Leeds united would return to the premiership

I wish people were taught in school about how our minds deceive us and about how to change negative beliefs about ourselves

I wish to be a grandad

I wish I could meet my granddaughter will all my heart

I wish I had a really nice family and friends

I wish I could get a cheap but good holiday this year

I wish somebody would tell _____ _____ to stop the madness

I wish I had power

I wish I had a sexy boyfriend

I wish my heart could be read by those I love because then they would believe me when I say sorry and they would know just how much I need them now and in the future

I wish I was pretty

I wish I had a ladybird to be my friend

I wish I could shop everyday

I wish I was a good girl

I wish I had more bread

I wish I had a lifetime of bowls

I wish I was beautiful

I wish people would stop bullying me about my runny nose

I wish I had a pony and 100 wishes

I wish to win the world championships

I wish for everyone to believe in god

I wish for a fit body

I wish I was strong

I wish I had a Ferrari

I wish I didn't have big ears

I wish I was tall dark and handsome but this is a wishing booth and not a miracle worker

I wish that me and my friends could be happy

I wish that my family was back to normal

I wish I could get a job

I wish I had a chance to speak out

I wish I could see my daughter more often

I wish I was cool

I wish I had a castle and I want to be a princess

I wish_____ never lived

I wish for a new hair band for my lovely cool hair

I wish I was a millionaire

I wish I could go out with _____ she is so so
so so so so so so so so so so so so so so so so so
so so so so so so so so so so so so so so so so so
so so so so so so so so so so so so so so so so so
so so so so so so so so so so so so so so so so so
so so so so so so so so so so so so so so so so so
so so so so so so so so so so fit

I wish I was the fastest in the world

I wish when I meet _____ I have a fit body

I wish I would grow up to be wealthy, have a good
job and a boy child

I wish I had a thousand wishes and I wish for
everything I dream of

I wish I was gay

I wish people would respect one another take time
to get to know each other regardless of....

I wish I had loadsa money

I wish I was sexier

I wish I could have a girlfriend

I wish I had a big bum

I wish the bullies would stop in all schools

I wish I had a father

I wish I was loved

I wish I was a good girl because I am quite naughty

I wish I won the lottery and £100

I wish for me and _____ and _____ to be
best friends forever

I wish _____ could be good

I wish I had a brother

I wish there was room for me in Mali this year

I wish for a good man

I wish for a long happy life

I wish for dishes and plates but one day for a
whole lot more

I wish I am the one picked for the job of a lifetime

I wish I could complete on my house purchase

I wish my feature film gets made this year

I wish for a permanent home which is happy for
years to come

I wish for more hours in the day

I wish I could have lots of sweets

I wish I could run slow

I wish I was a milkman

I wish that I didn't have small legs

I wish I was born with special powers

I wish I had bigger breasts and a flatter stomach

I wish that _____ was my boyfriend
tomorrow and he told me his feelings and
he told me in registration

I wish for resilience, truth throughout

I wish to be happy with monkey and for sister
to get better

I wish for health, strengths and happiness for myself
friends and family and that god will continue to give
me courage to continue with my work of helping
others to reach their full potential

I wish that everything is okay

I wish that _____ will always be happy

I wish that the there will be more appreciation of
beauty and more love of the diversity of people and
for wealth and happiness for me and all

I wish that I could live in Australia

I wish for decent art in Leicester

I wish that my future will be successful

I wish I had a big willy

I wish my Mum was still alive

I wish I was born on Christmas Day

I wish my great auntie got a liver transplant

I wish I could be a pink butterfly and fly over the
rainbows and scatter magic fairy dust and make
people happy

I wish Dad would be cured

I wish that I could have kids

I wish my great-grandad will recover from cancer
and also my great gran is peaceful

I wish that I was nice

I wish that no one cried

I wish that my Dad would get better and we could
go on a family holiday

I wish my Mum would quit smoking

I wish I was a super man

biography sally sheinman

Sally Sheinman is an American who grew up on a dairy farm close to the Canadian border and also worked on Wall Street. She received a BA Degree from the State University of New York at Albany. She undertook postgraduate studies at Hunter College, New York City, where her tutors included Tony Smith and Robert Morris. Sally has lived in the UK for the last 20 years. She is a prolific painter and committed to a rigorous work schedule. Her recent exhibitions include:

Sacred Vessels, a touring exhibition
Rugby Art Gallery and Museum, Rugby, 2003

Days, a touring exhibition
The Gallery, Stratford-upon-Avon, 2002

The Naming Room
Roadmender, Northampton, 2001

Fragments of Time and Thought
Liberty, London, 2000

Artjongg
University College Northampton, 1999

Between the Lines
Ikon Touring, Birmingham, 1997

New Work
City Gallery, Leicester, 1995

with thanks

Thank you to all who shared their wishes, and to the six Leicester venues who displayed the Wishing Ceremony booths:
Braunstone Leisure Centre
LCB Depot
The Ark
Arts Training Central
Sir Jonathan North Community College
Pakistan Youth and Community Centre

This catalogue has been published by the University of Hertfordshire to accompany the exhibition
The Wishing Ceremony
Art and Design Gallery
College Lane, Hatfield, Hertfordshire AL10 9AB
01707 285376
23 September – 1 November 2005

Sanna Moore, Curator and Gallery Administrator
Matthew Shaul, Head of Programming and Operations

Essays by Sanna Moore, Laura Gascoigne and Fiona Clayton
Edited by Sanna Moore and Elizabeth Leroy

ISBN 1 898543 99 2

A catalogue record for this publication is available from the British Library

© University of Hertfordshire
All works © the artist
All photography © the photographers
Technician James Macdonald